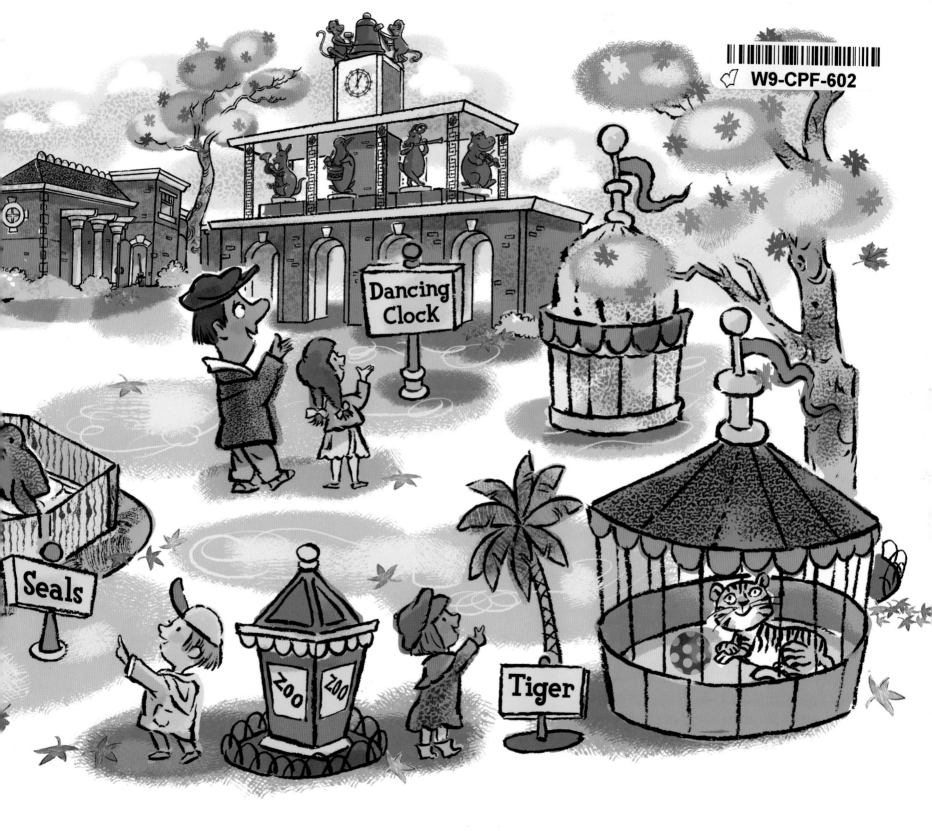

To Ryan, Sophie,
Brigitte, and Sheila
—S.M.

For Ann, Evan, and Arthur
—J.A.N.

tiger tales
an imprint of ME Media, LLC
5 River Road, Suite 128, Wilton, CT 06897
Published in the United States 2011
Text copyright © 2011 Steve Metzger
Illustrations copyright © 2011 John Abbott Nez
CIP data is available
Hardcover ISBN-13: 978-1-58925-100-7
Hardcover ISBN-10: 1-58925-100-8
Paperback ISBN-13: 978-1-58925-429-9
Paperback ISBN-10: 1-58925-429-5
Printed in China
LPP 0111
1 3 5 7 9 10 8 6 4 2
For more insight and activities, visit us at www.tigertalesbooks.com

The Dancing CLOCK

by Steve Metzger

Illustrated by John Abbott Nez

tiger tales

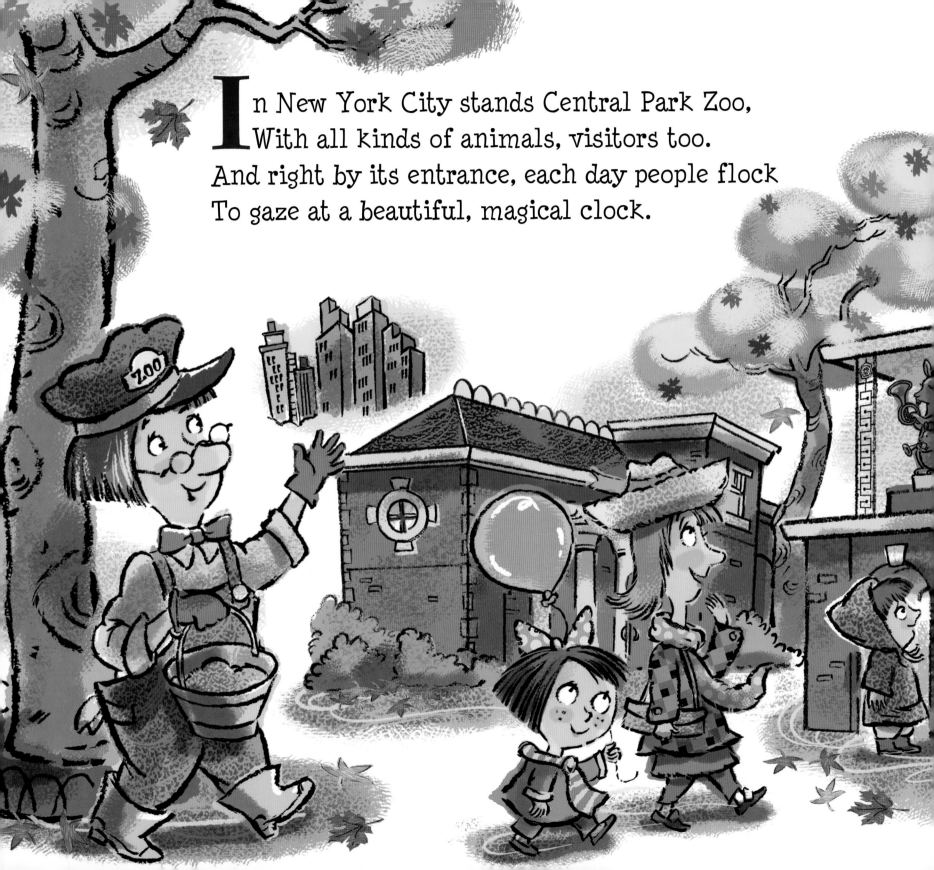

In New York City stands Central Park Zoo,
With all kinds of animals, visitors too.
And right by its entrance, each day people flock
To gaze at a beautiful, magical clock.

At every hour—yes, right on the dot—
No matter whether it's wintry or hot,
Two monkeys ring a shiny brass bell.
Animals spin. The sound of chimes swell.

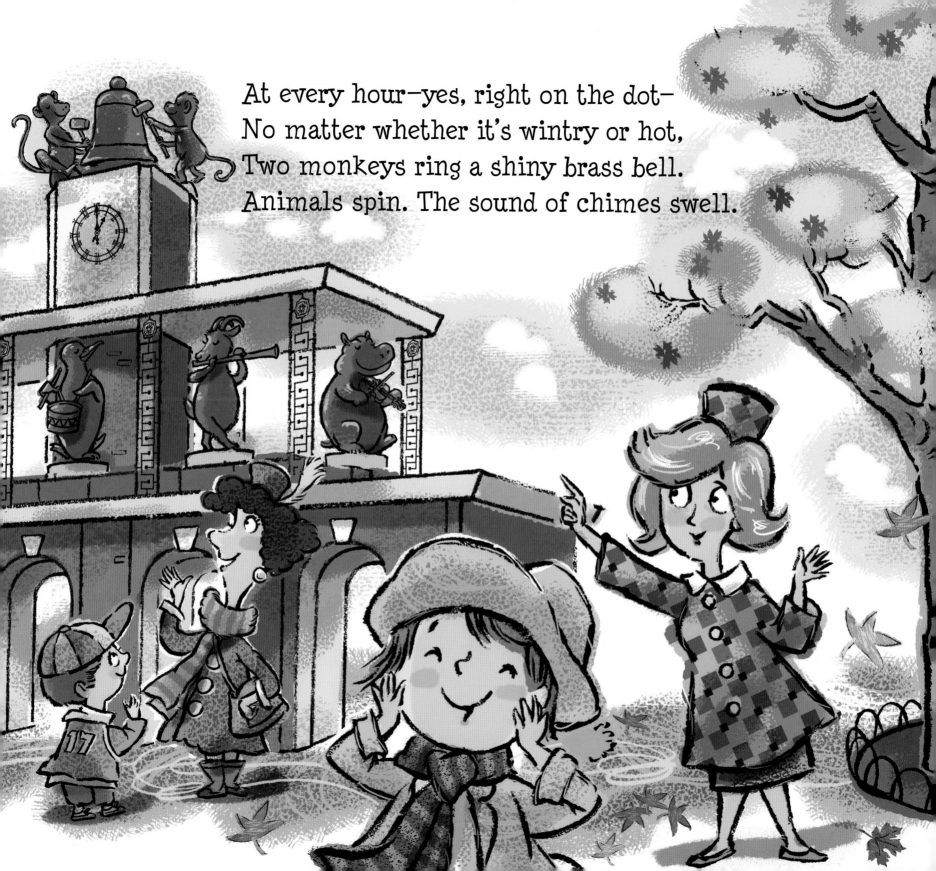

The hippo starts playing his fiddle with bow.
The goat holds her panpipes, she's ready to blow.
The elephant's squeezebox goes out and then in,
And that bear's tambourine—a marvelous din!

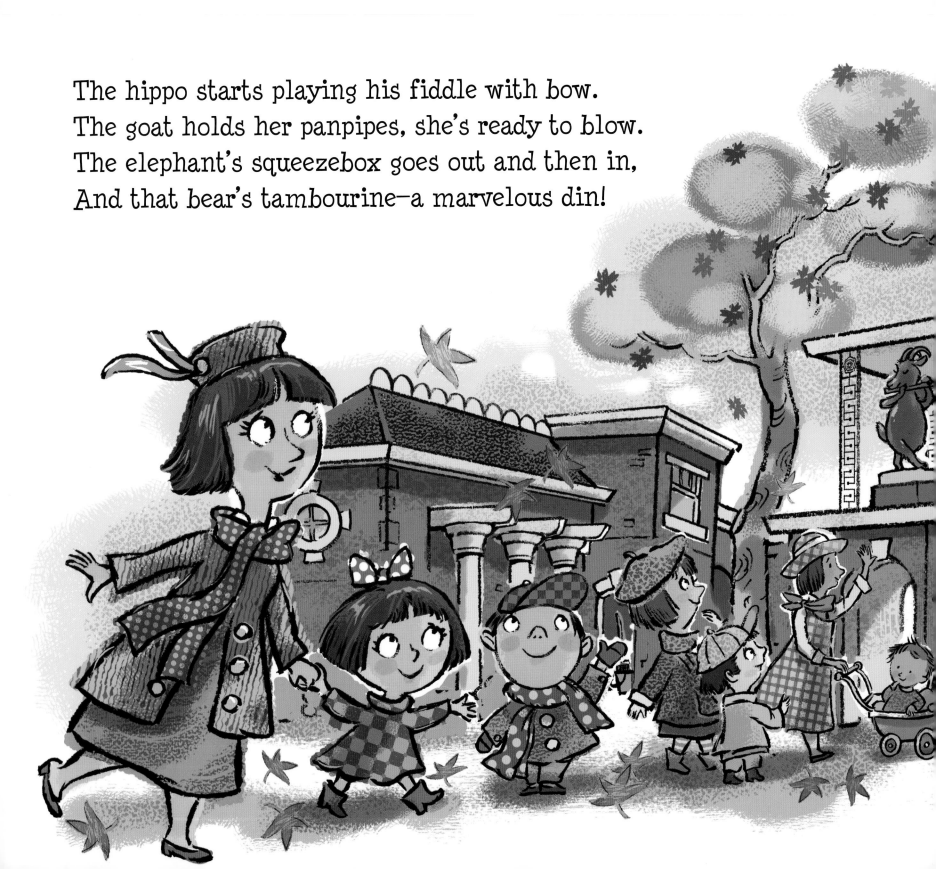

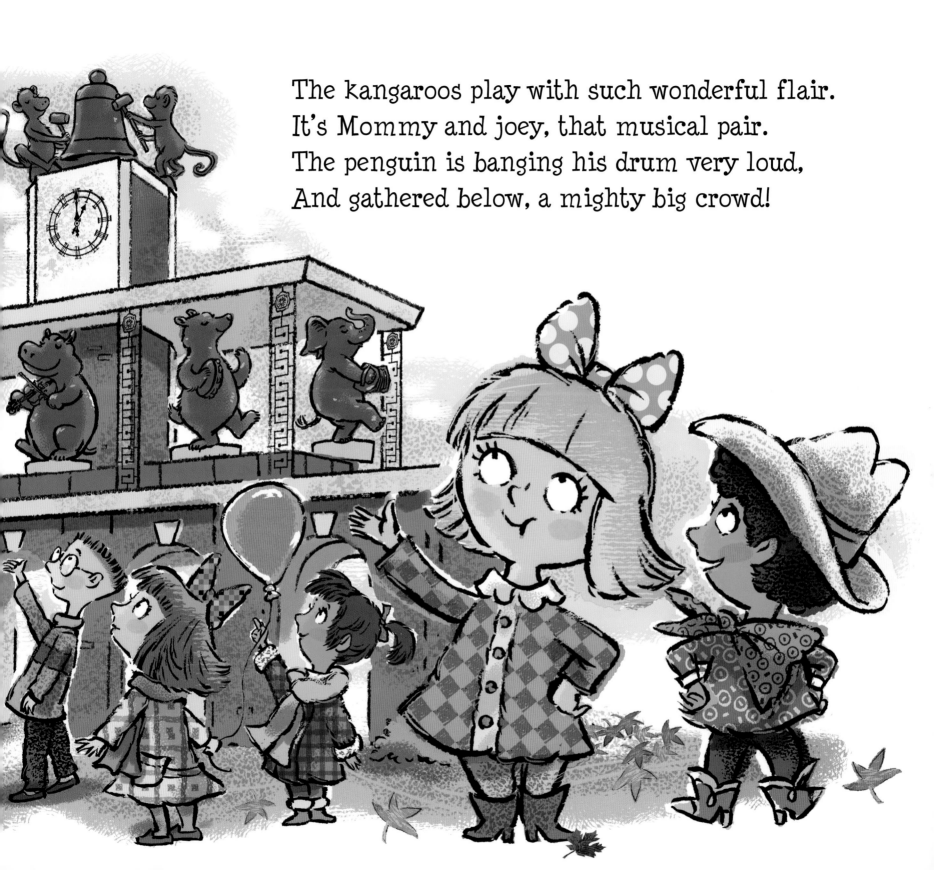

The kangaroos play with such wonderful flair.
It's Mommy and joey, that musical pair.
The penguin is banging his drum very loud,
And gathered below, a mighty big crowd!

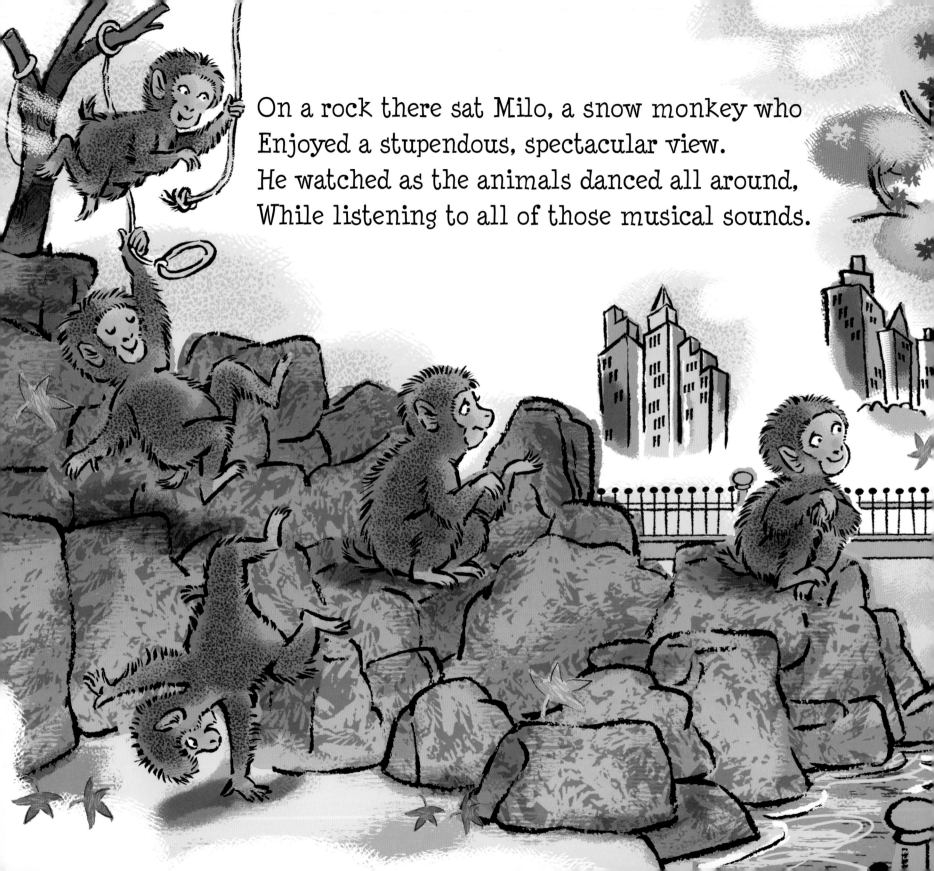

On a rock there sat Milo, a snow monkey who
Enjoyed a stupendous, spectacular view.
He watched as the animals danced all around,
While listening to all of those musical sounds.

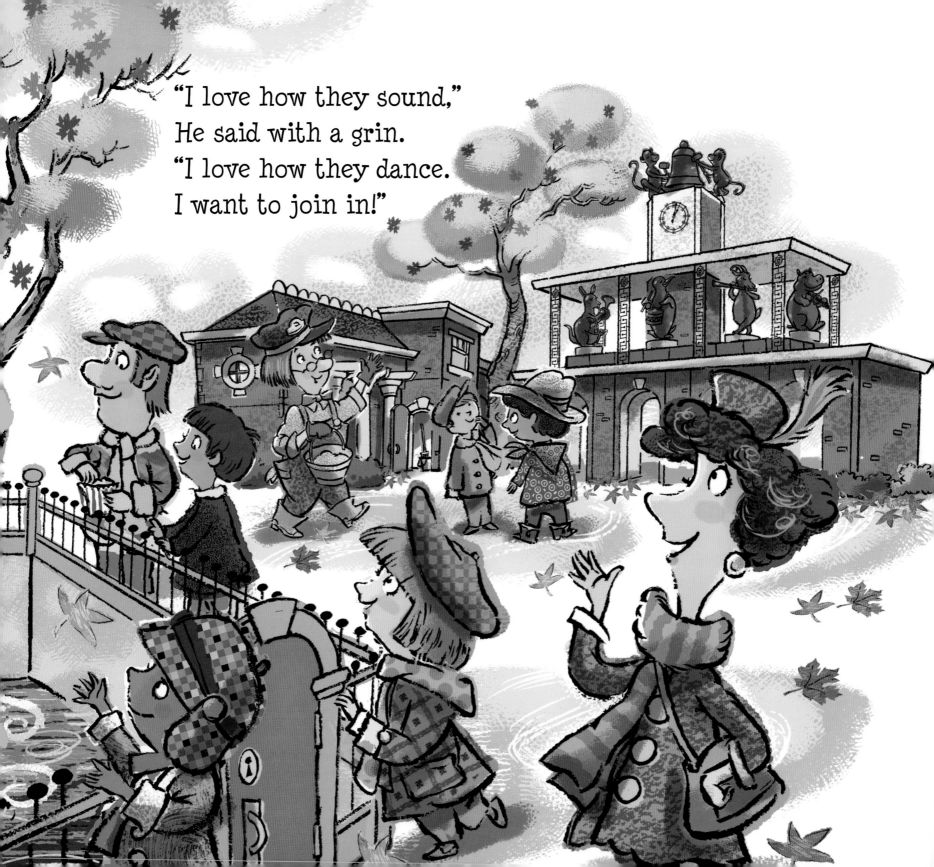

"I love how they sound,"
He said with a grin.
"I love how they dance.
I want to join in!"

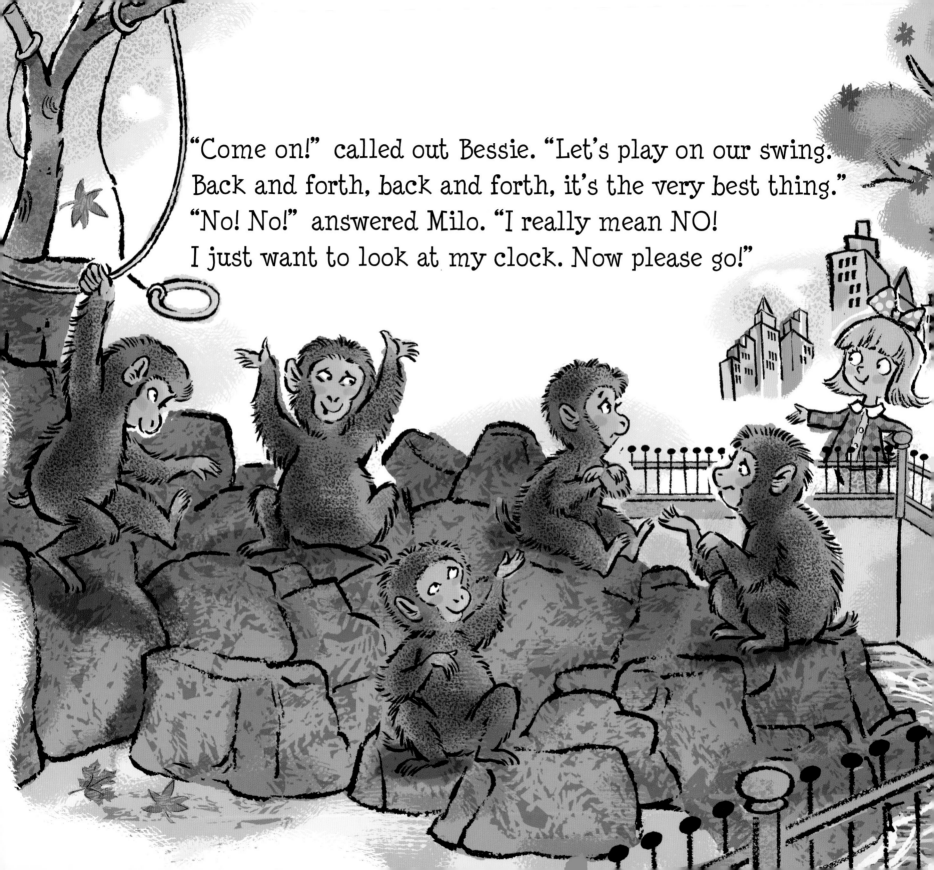

"Come on!" called out Bessie. "Let's play on our swing.
Back and forth, back and forth, it's the very best thing."
"No! No!" answered Milo. "I really mean NO!
I just want to look at my clock. Now please go!"

For twenty-two days, Milo's friends really tried.
"He won't leave that spot. It's no use," Leon sighed.
"Let's go, fellow monkeys," Zack cried out to Gus.
"He must love that silly old clock more than us."

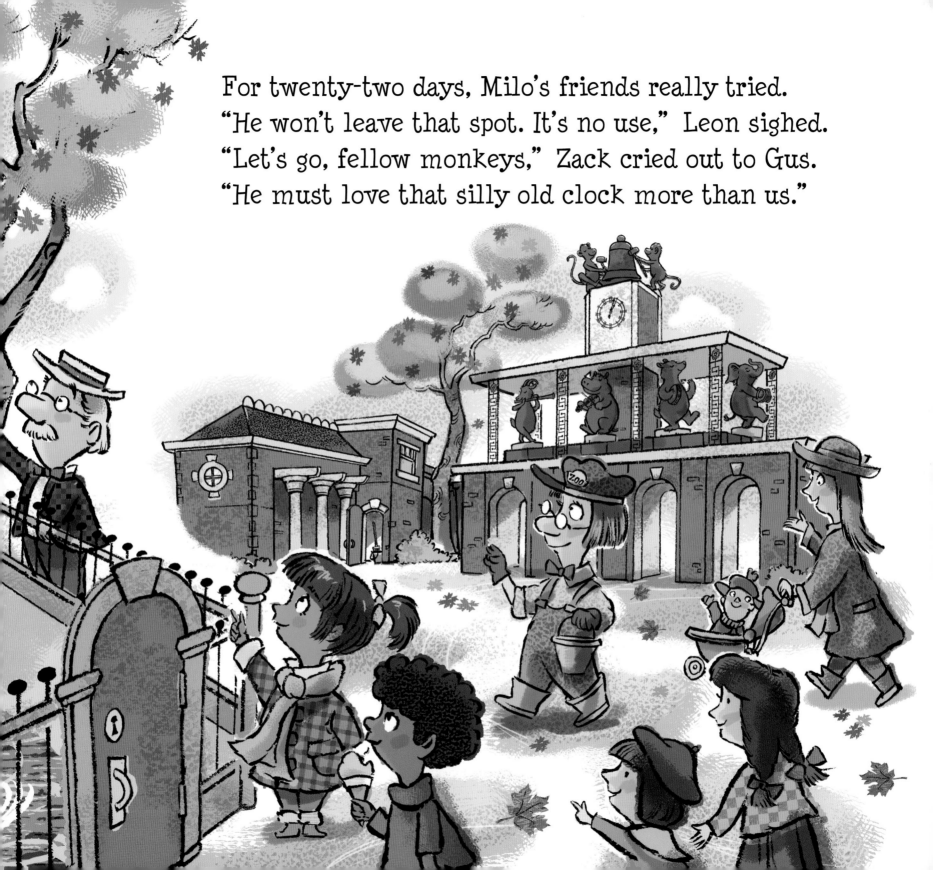

It actually happened the very next day.
The zookeeper checked to see all was OK.
As Milo was dreaming again of his clock,
He glanced at the door and then noticed... *no lock!*

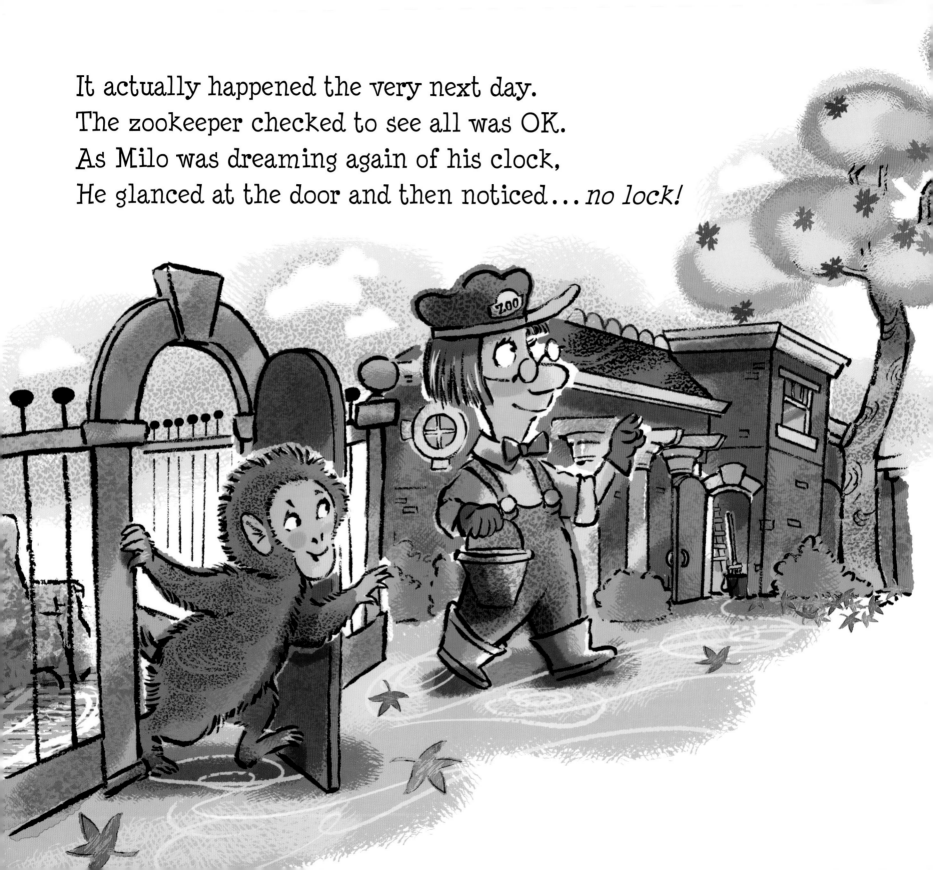

He shot up a ladder and into a room,
With buckets and mops, a sink and a broom.
Out through a window, he scampered and scurried.
Onto a tree branch, he hastily hurried.

That Milo, brave monkey, he gathered his will,
He jumped . . .

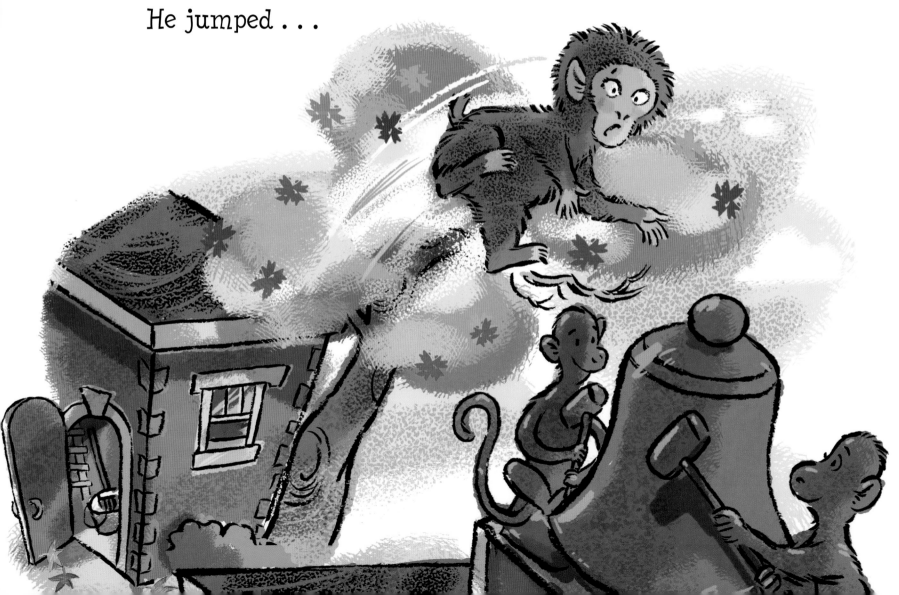

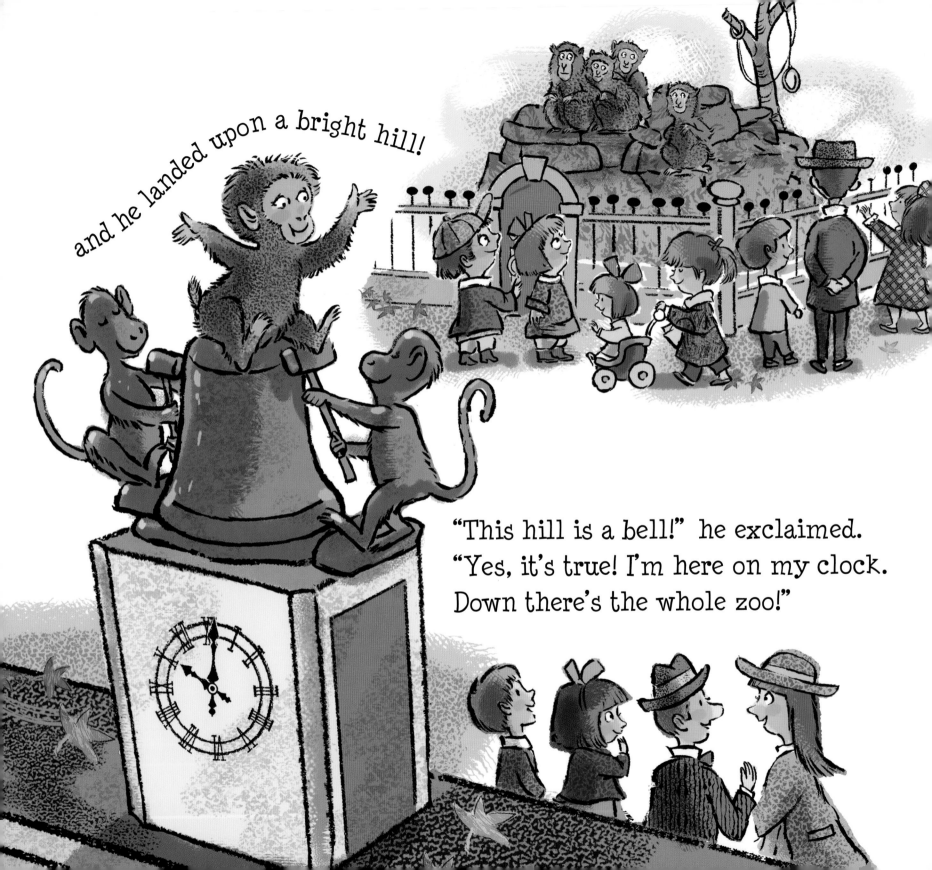

and he landed upon a bright hill!

"This hill is a bell!" he exclaimed.
"Yes, it's true! I'm here on my clock.
Down there's the whole zoo!"

He looked all around and just about then,
The ringing began, the clock had struck ten.
"They're moving!" he shouted. "Now here's my chance.
I'm going to join the musicians and dance!"

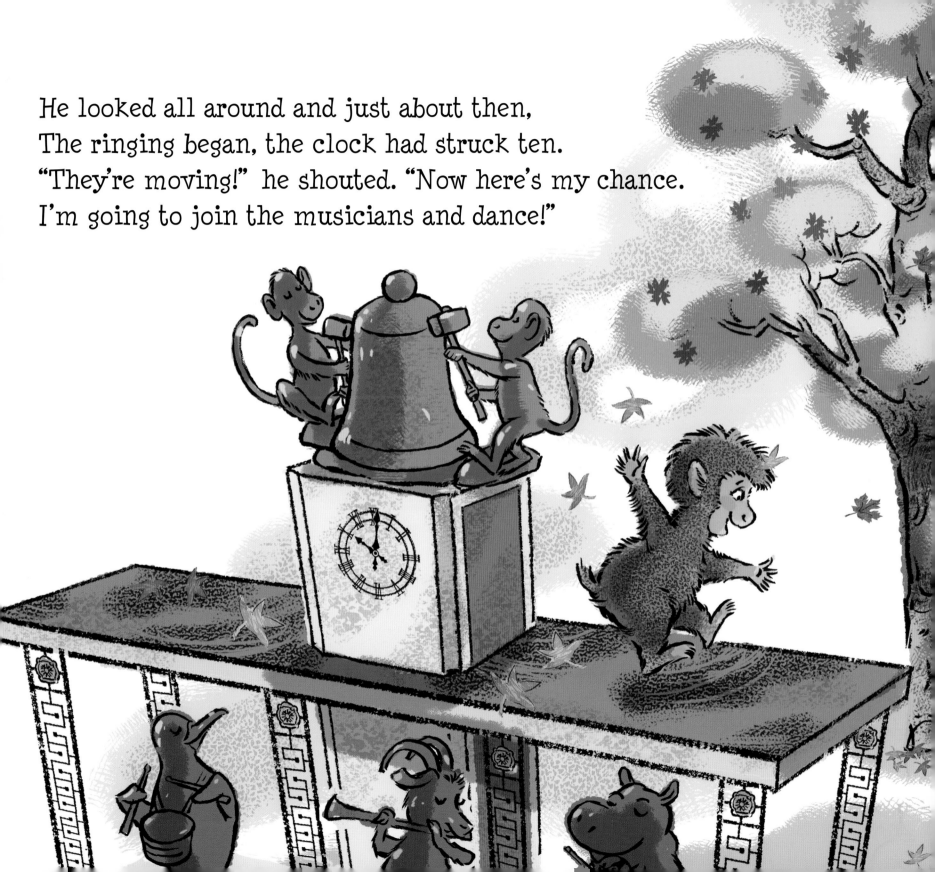

The people below didn't see him at all,
Except for a girl with a hat and a ball.
She pointed and said, "There's a real monkey here!"
Then everyone saw him and started to cheer.

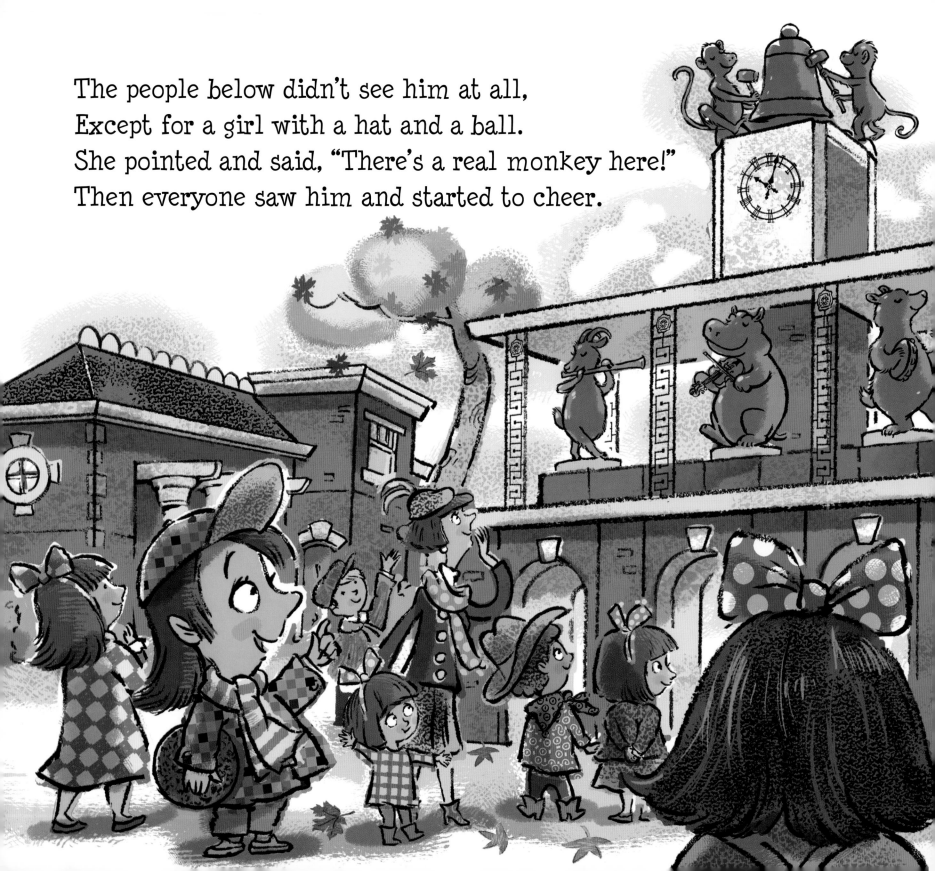

He jumped on the hippo, he bounced on the bear,
Spinning and gliding, like floating on air.
He banged on the drum and when he was through,
Happily danced with each kangaroo.

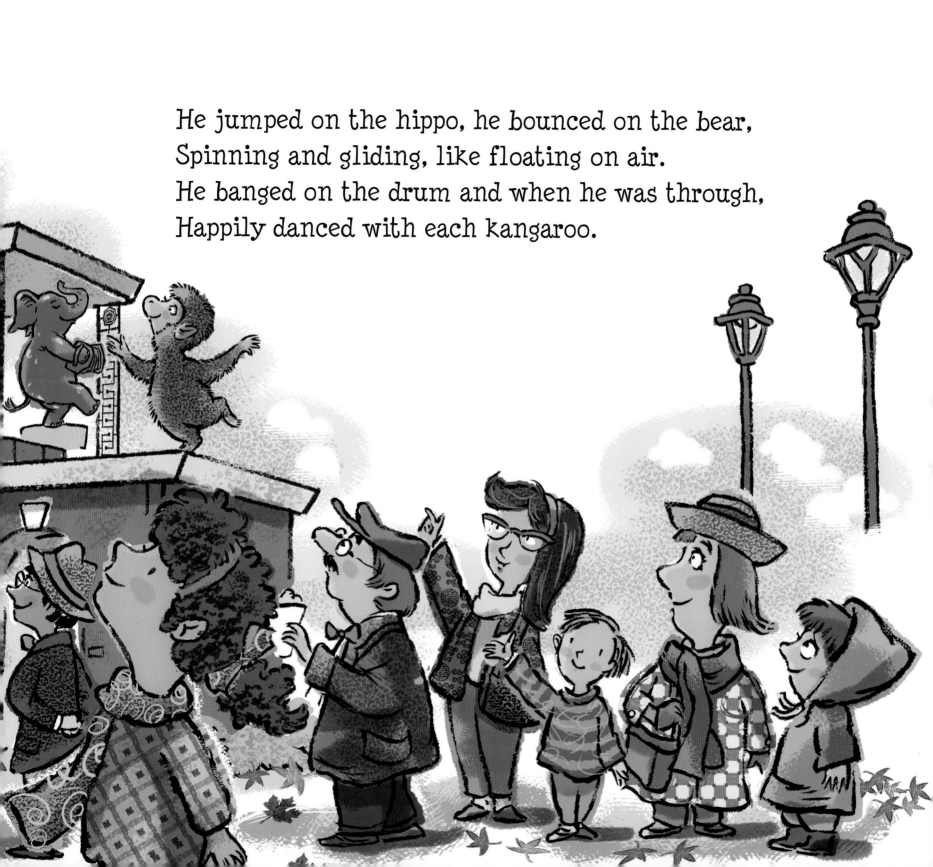

He waved, and he bowed. The crowd yelled, "HOORAY!"
The music had ended, he wished he could stay.
But now I feel hungry, he suddenly thought.
What kind of food has the zookeeper brought?

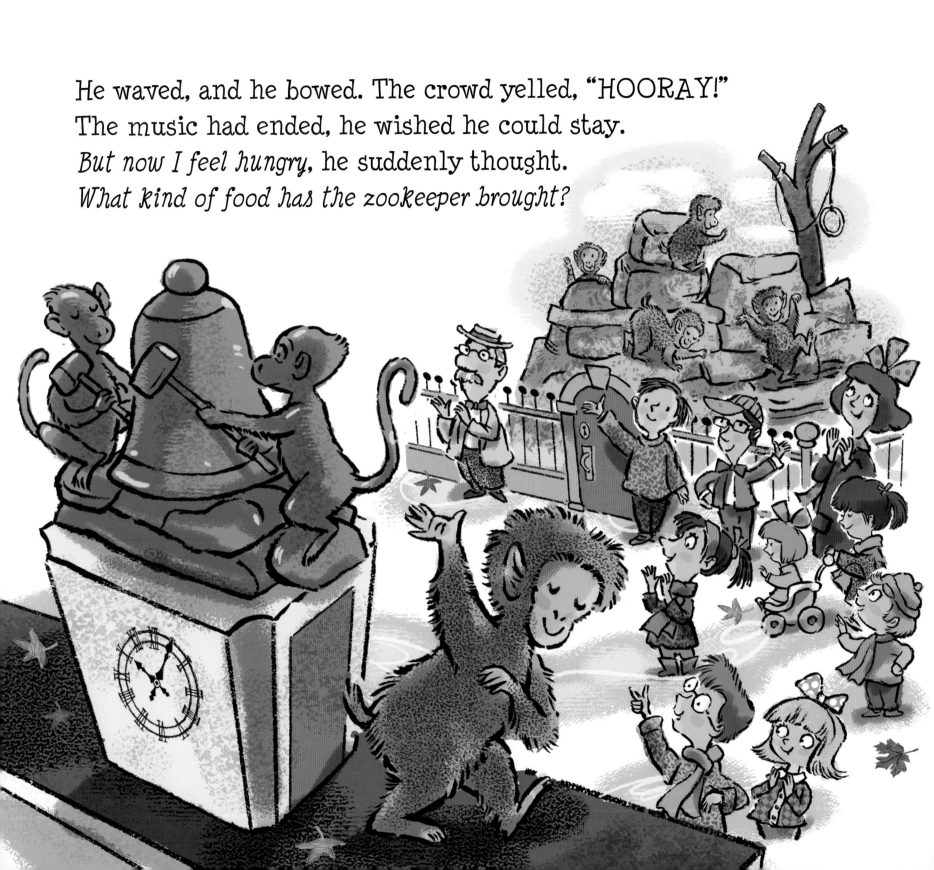

He started to leave, but received quite a shock.
He saw that his gate was now shut with a lock!

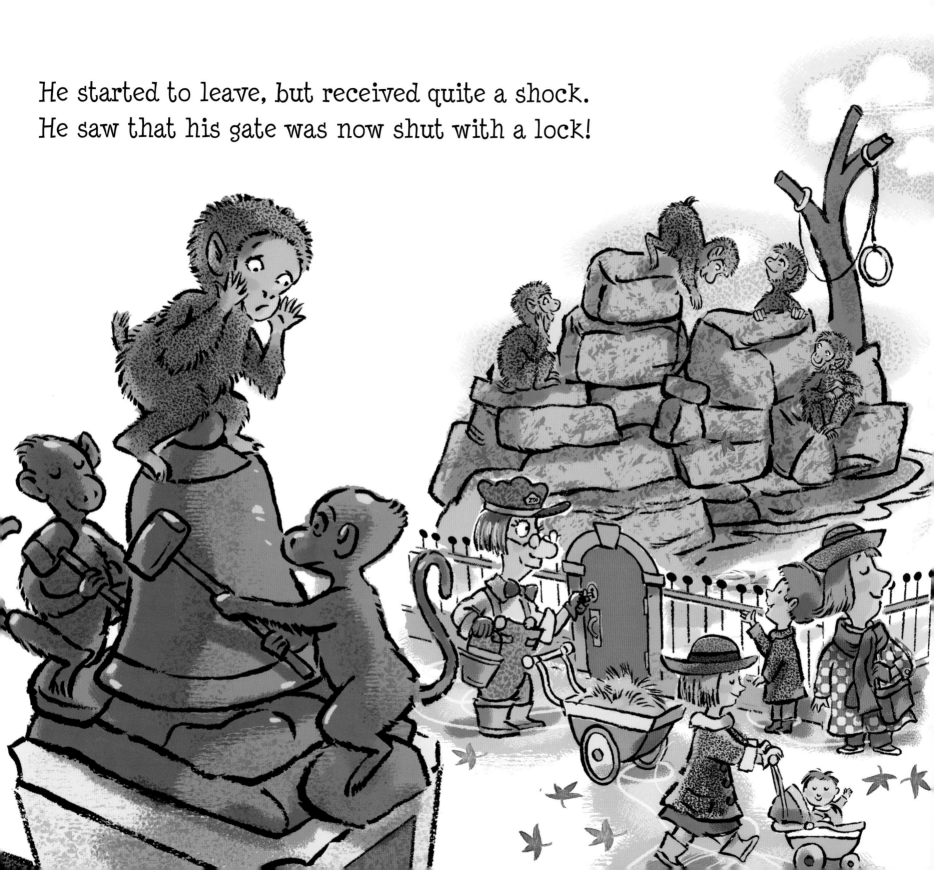

He looked at the monkeys from up on the bell,
All having a really great time, he could tell,
Laughing and eating and swinging from trees.
"I want to go home, but I don't have the keys."

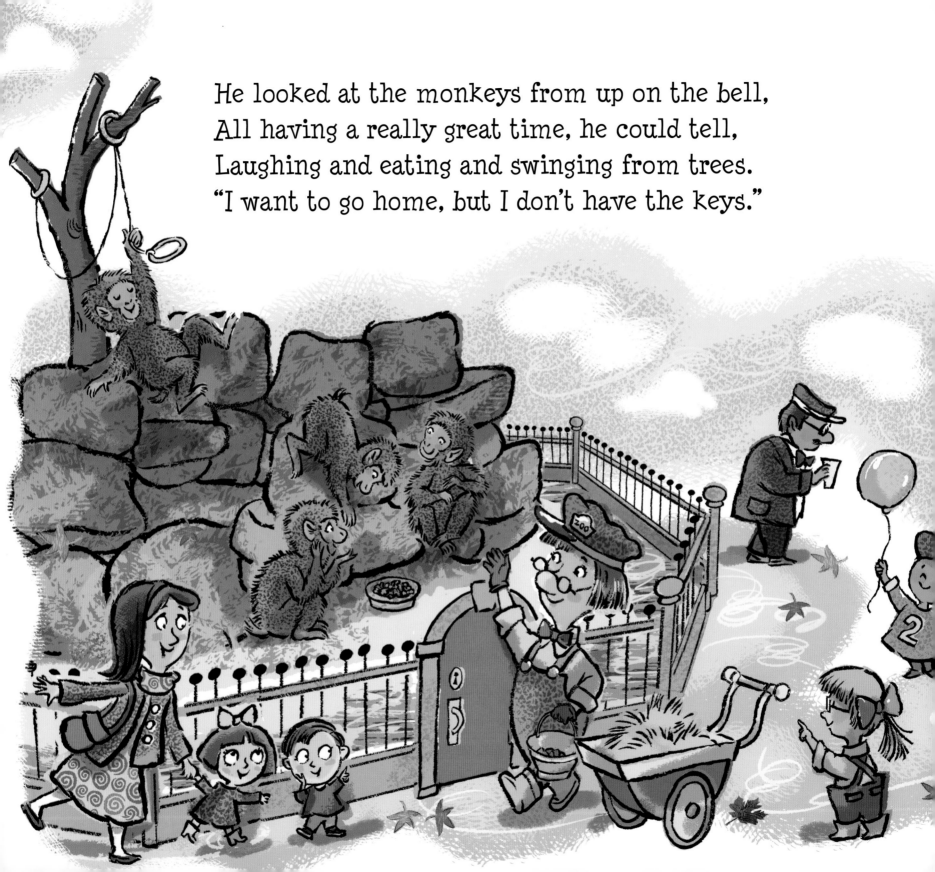

He loved his fine clock whether dancing or still,
But now there were clouds. The air had a chill.
He hugged the musicians; he gave each a try.
Their bodies were cold. He was ready to cry.

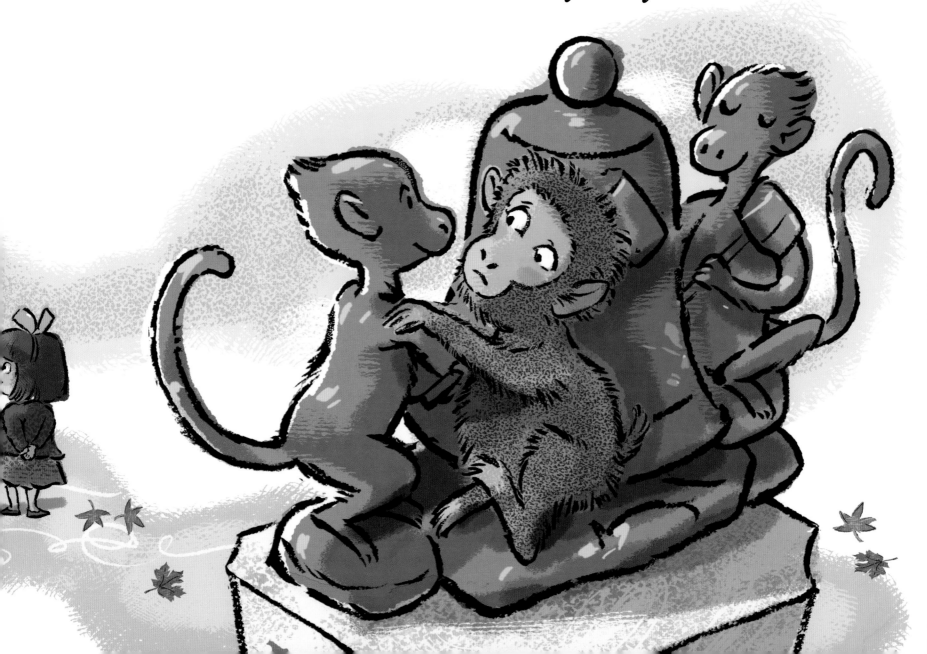

Then Milo saw someone coming his way.
It was the zookeeper, carrying hay!
Grabbing a nut, he knew not to chew it.
He took careful aim, wound up, and then threw it....

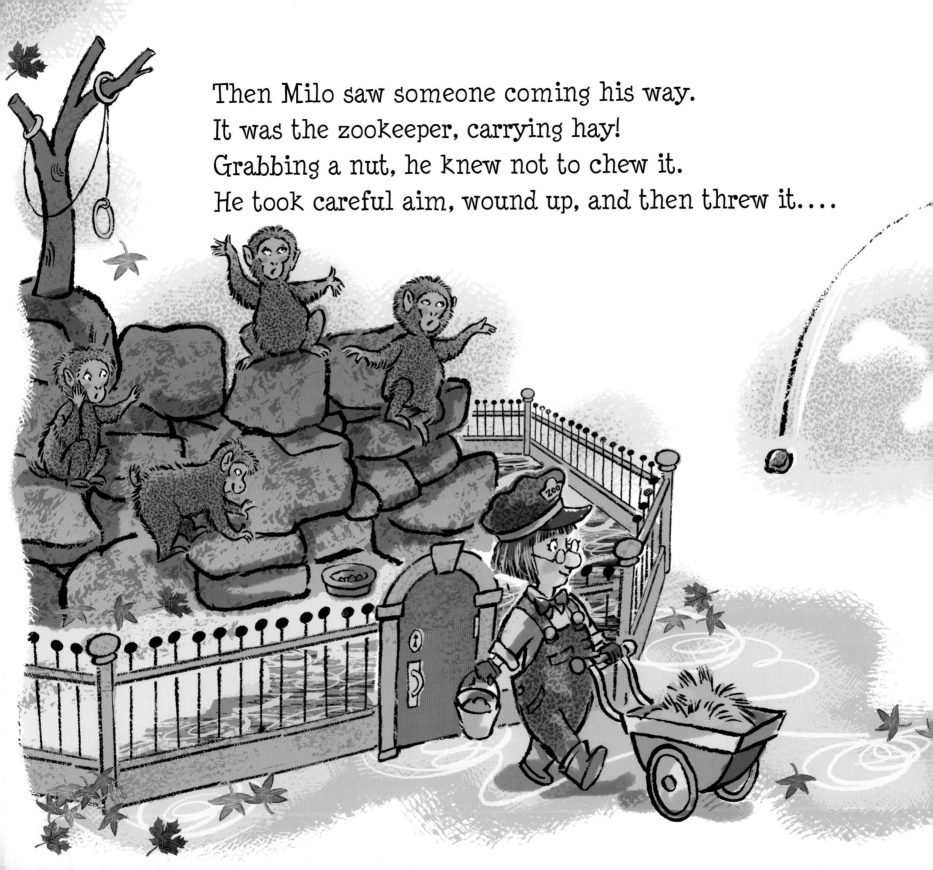

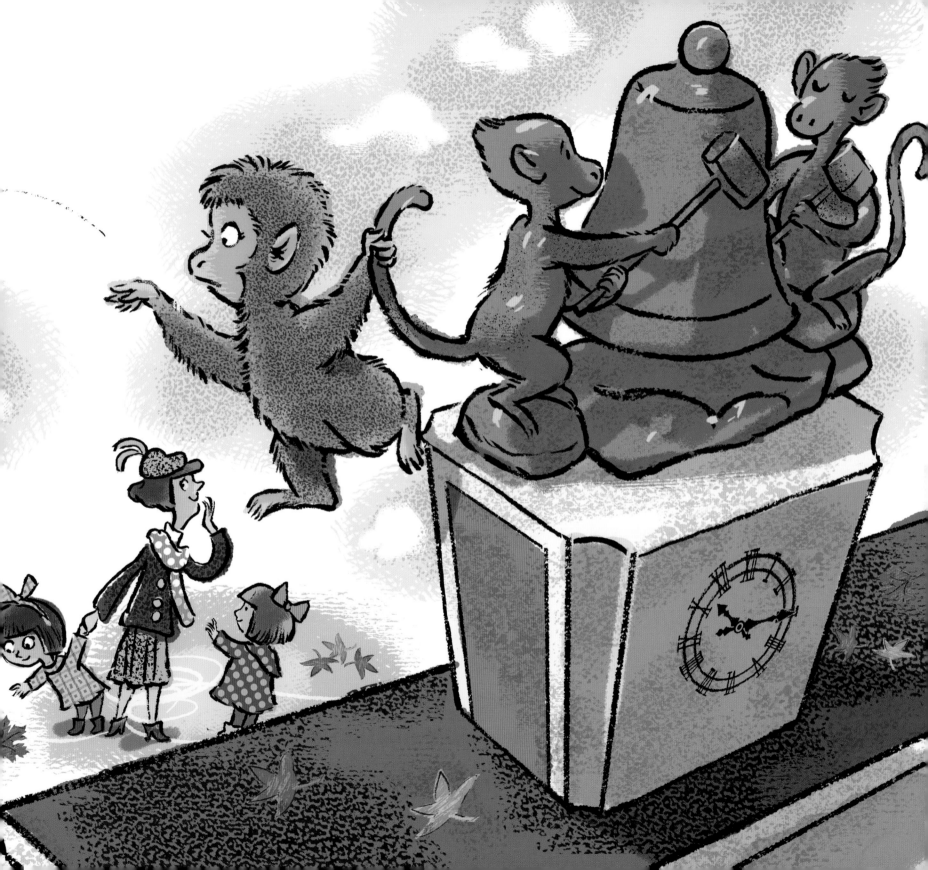

She quickly looked up, her eyes opened wide.
"Why Milo, you rascal, how'd *you* get outside?
Come down, silly monkey, please don't be shy.
I'll take you right home, my brave little guy."

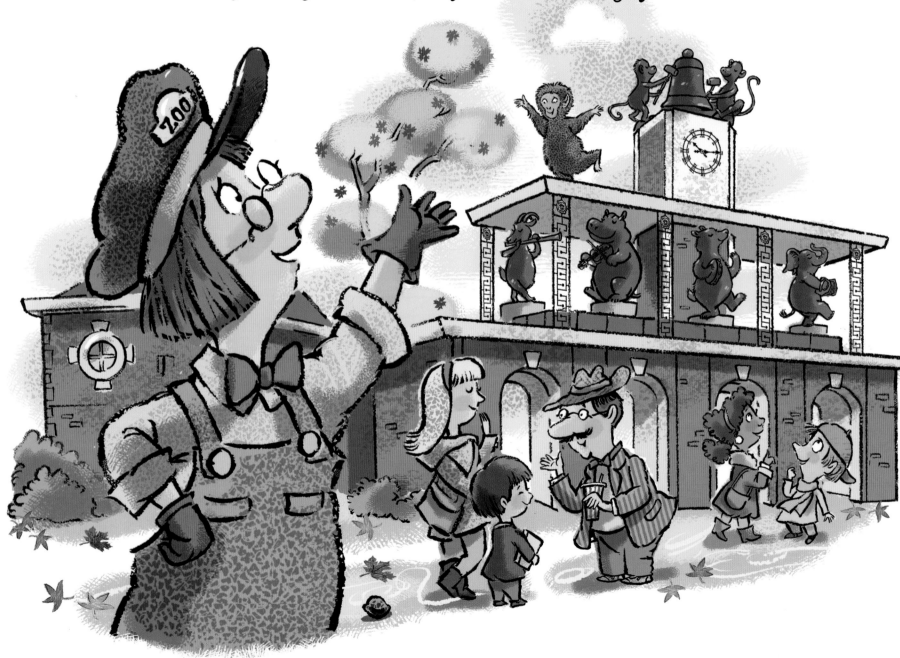

The zookeeper opened the lock with her key.
She let Milo in...and what did he see?

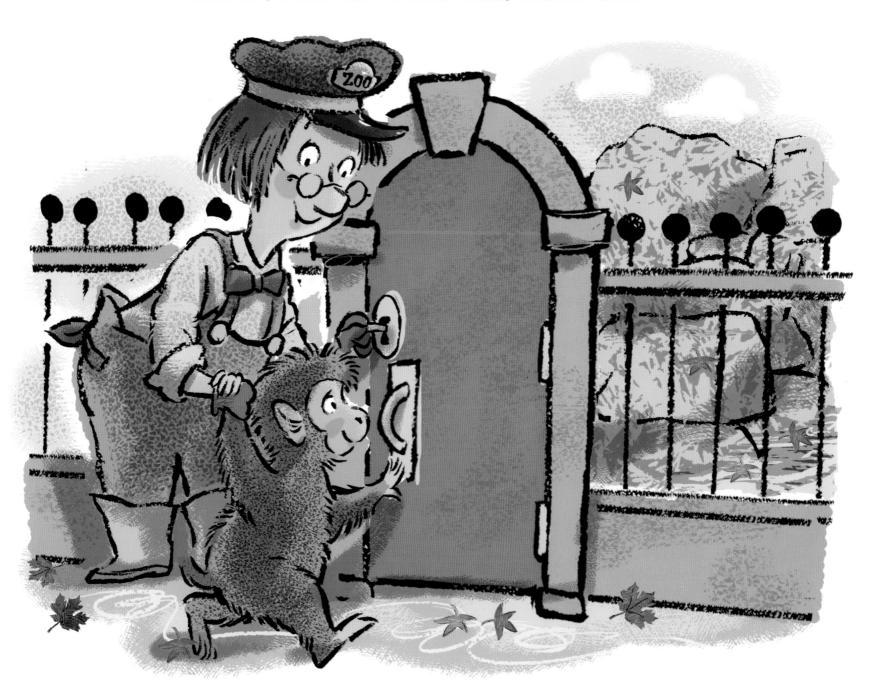

Yelling and jumping and screeching and shouting,
Hugging and climbing and running abouting!
"I've missed you!" said Milo. "I just won't pretend.
A clock can be special, but not like a friend!"

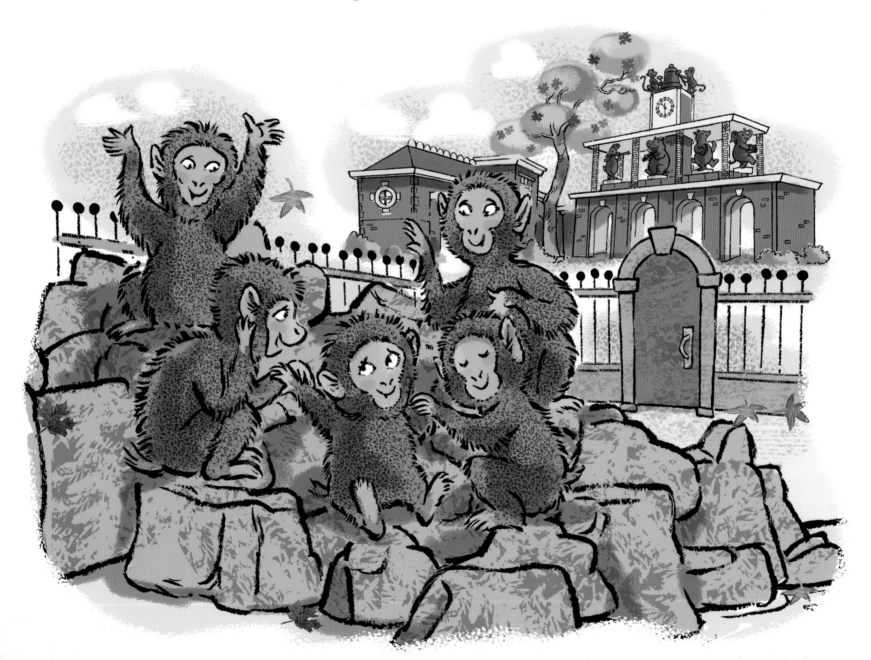

About the Dancing Clock

A trip to New York City wouldn't be complete without visiting the Empire State Building or the Statue of Liberty. But there's another sight that also shouldn't be missed. It's the Delacorte Clock, located outside the entrance to the Central Park Children's Zoo.

The Delacorte Clock has enchanted New Yorkers and tourists for decades. Dedicated in 1965, it was a gift from publisher and philanthropist George T. Delacorte. The clock's design was inspired by the musical clocks Delacorte had seen on his trips throughout Europe.

The Delacorte Clock features a whimsical band of bronze animals: a penguin, two kangaroos, a bear, an elephant, a goat, and a hippopotamus. Each animal, created by the Italian sculptor Andrea Spadini, plays a different musical instrument.

Every hour, between 8:00 A.M. and 6:00 P.M., two monkeys strike hammers against a bell, counting out the time. On the hour and half hour, the other animals rotate around the clock and play songs and nursery rhymes. The tunes include "Sing a Song of Sixpence," "Three Blind Mice," and "Mary Had a Little Lamb."

When visiting the Delacorte Clock, you can find real snow monkeys nearby in the Central Park Zoo.

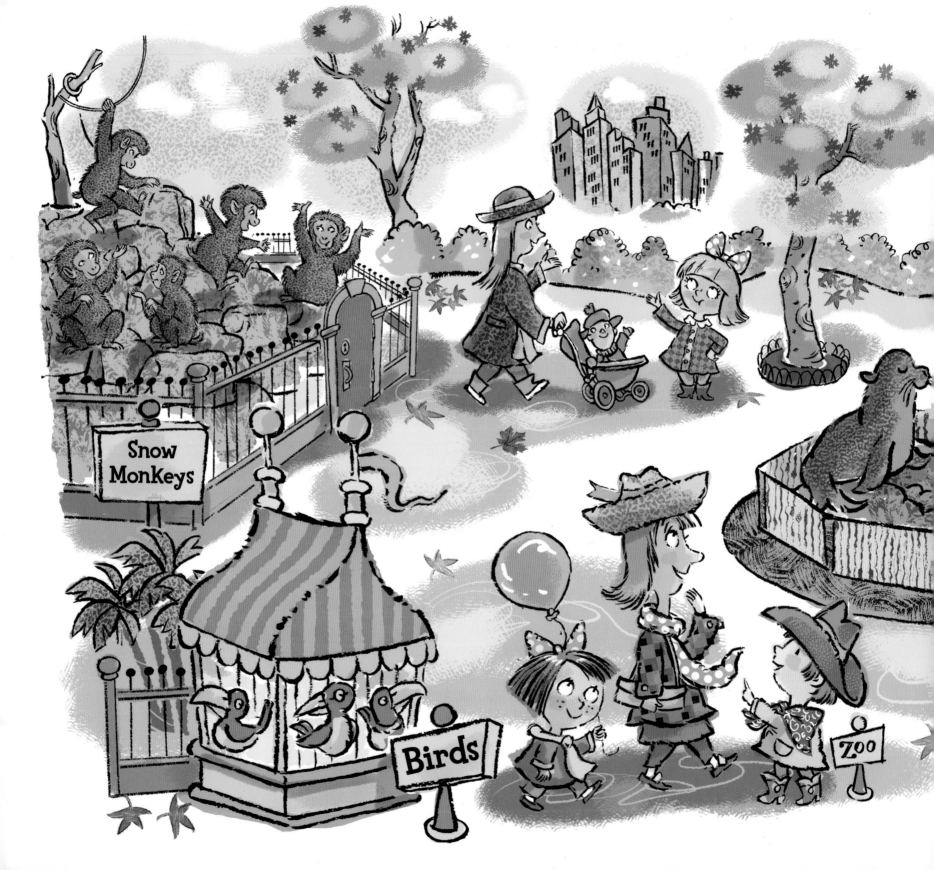

Snow
Monkeys

Birds

Zoo